SHALOM
COLORING

Jewish Designs for Contemplation and Calm

with artwork by

Freddie Levin and Judy Dick

BEHRMAN HOUSE

www.behrmanhouse.com

To Alice Binney
—FREDDIE LEVIN

To my mother, whose eye for
beauty has inspired my love of detail,
and Grandma, the artist I wanted
to be like when I grew up.
—JUDY DICK

PROJECT EDITOR: Ann D. Koffsky
DESIGNER: Annemarie Redmond

Images on pages 25, 41, 65 Copyright © 2016 Ann D. Koffsky
All other images, Copyright © 2016 Behrman House, Inc.
Springfield, NJ 07081
ISBN: 978-0-87441-941-2
Printed in the United States of America

Library of Congress Cataloging-in-Publication Data
Levin, Freddie, author.
 Shalom Coloring : Jewish Designs for Contemplation and Calm ; with
artwork by Freddie Levin and Judy Dick.
 pages cm
 ISBN 978-0-87441-941-2
 1. Jewish way of life. 2. Coloring books. I. Dick, Judy, co-author. II. Title.
 BM723.L465 2015
 296.7'2--dc23
 2015028752

Art credits:
Freddie Levin: Back cover, 3-7, 11, 15, 17, 21, 25, 29, 31, 35-39, 43-60, 63, 67, 69, 71
Judy Dick: Cover, 1 , 9, 19, 23, 33, 41, 61, 72
Ann Koffsky: 13, 27, 65

Welcome to Shalom Coloring!

From Noah's rainbow of hope, to Joseph's coat of many colors, to today's vibrant blue on the flag of Israel, color and beauty have always been an integral part of Judaism's symbols and imagery. The artworks within these pages were each inspired by that rich history of beautifully crafted Jewish objects and motifs.

Yet, these illustrations are still unfinished—they await your own artistic contribution, and we invite you to bring your own creativity to them.

Choose whatever tools you prefer: Colored pencils, watercolors, gel pens, or brush markers will all work well. Choose colors that speak to you—from bold hues of reds and oranges, to pale pastels of lavenders and blues. The only limit is your own imagination, and whatever you decide, the results will be unique and lovely.

So enjoy yourself; relax into the beauty, pattern, and sayings within; and may they be an inspiration to you for calm and contentment, joy and happiness.

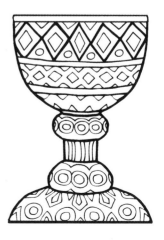

I have found nothing as
good for the body as silence.
It is not the study that is
the essence, but the practice.

—Pirkei Avot 1:17

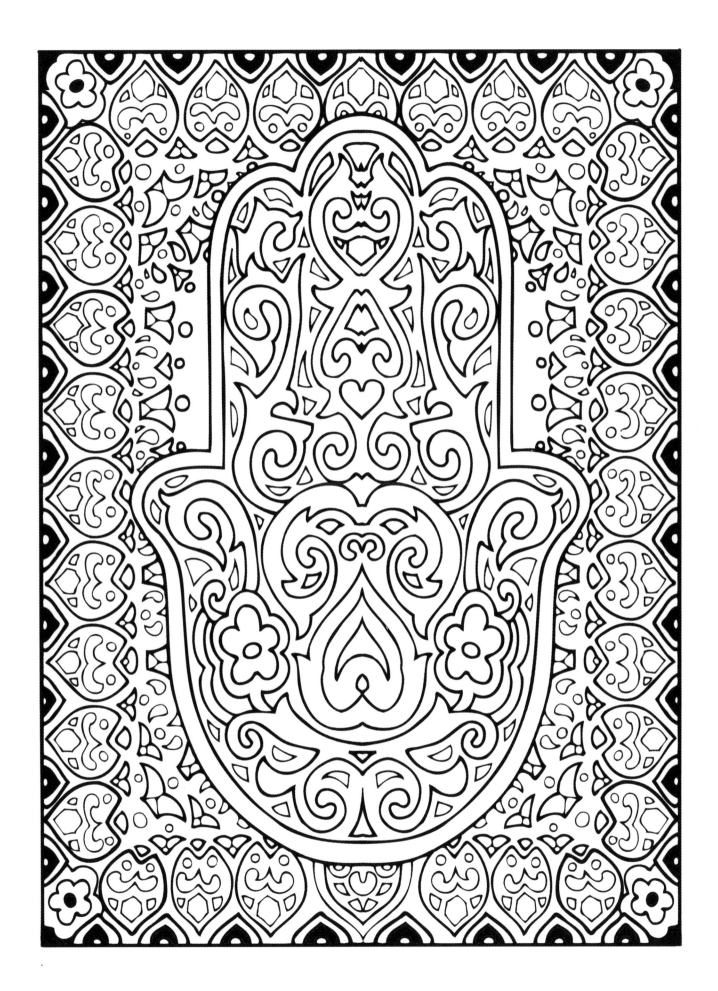

To everything there is
a season and a time for every
purpose under heaven.

—Ecclesiastes 3:1

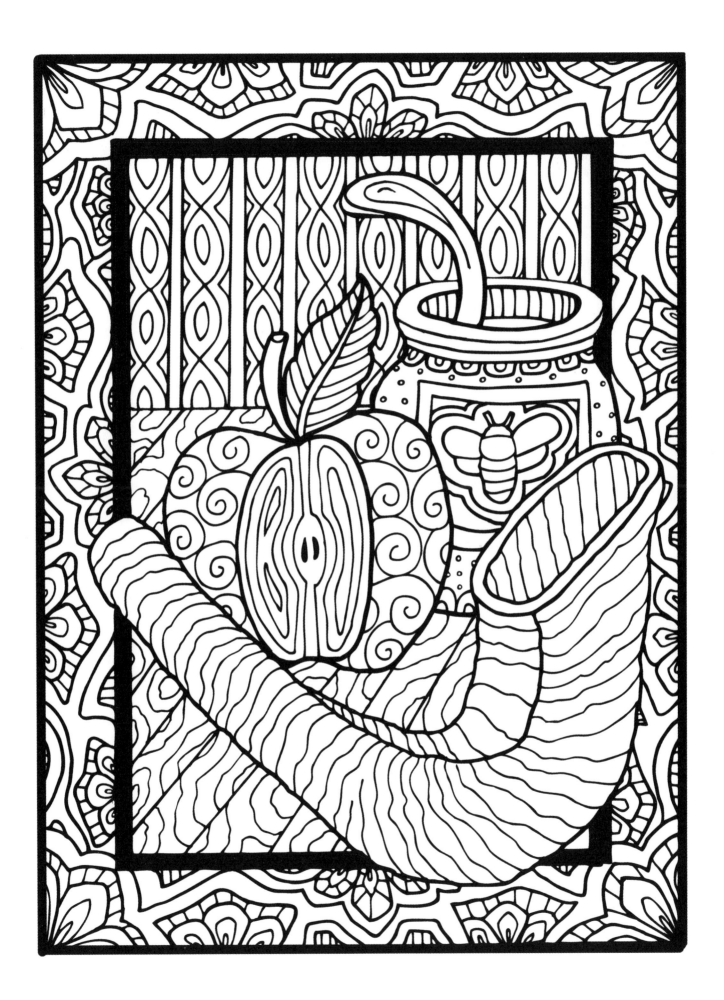

It is not your obligation to complete
the task, but neither are
you free to desist from it entirely.

—Pirkei Avot 2:21

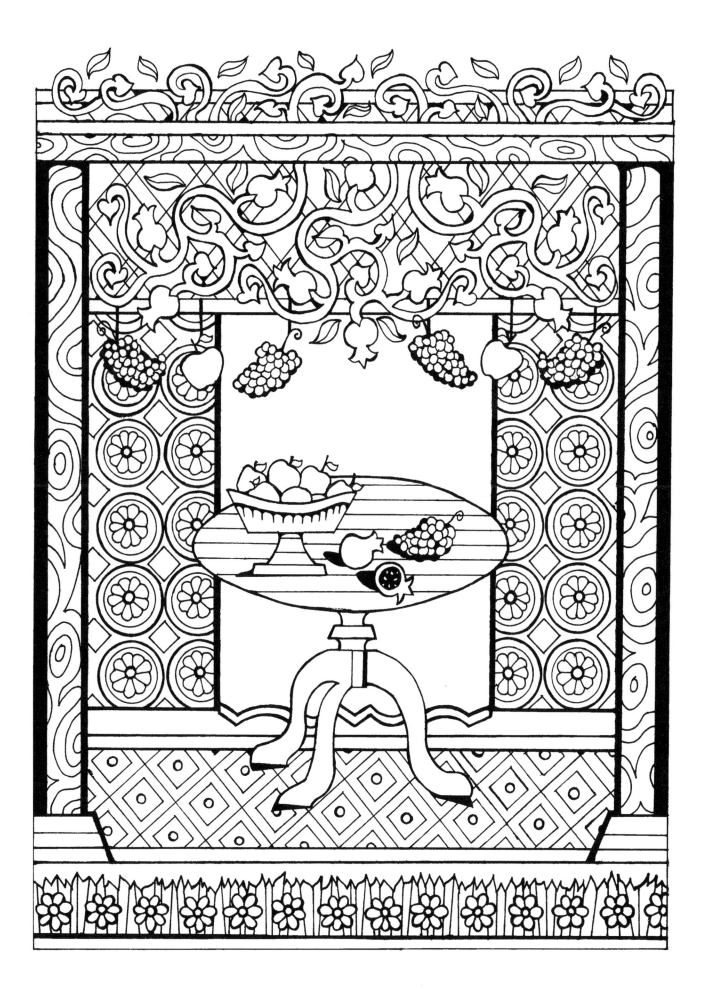

The righteous shall
flourish like the palm tree.

—Psalms 92:13

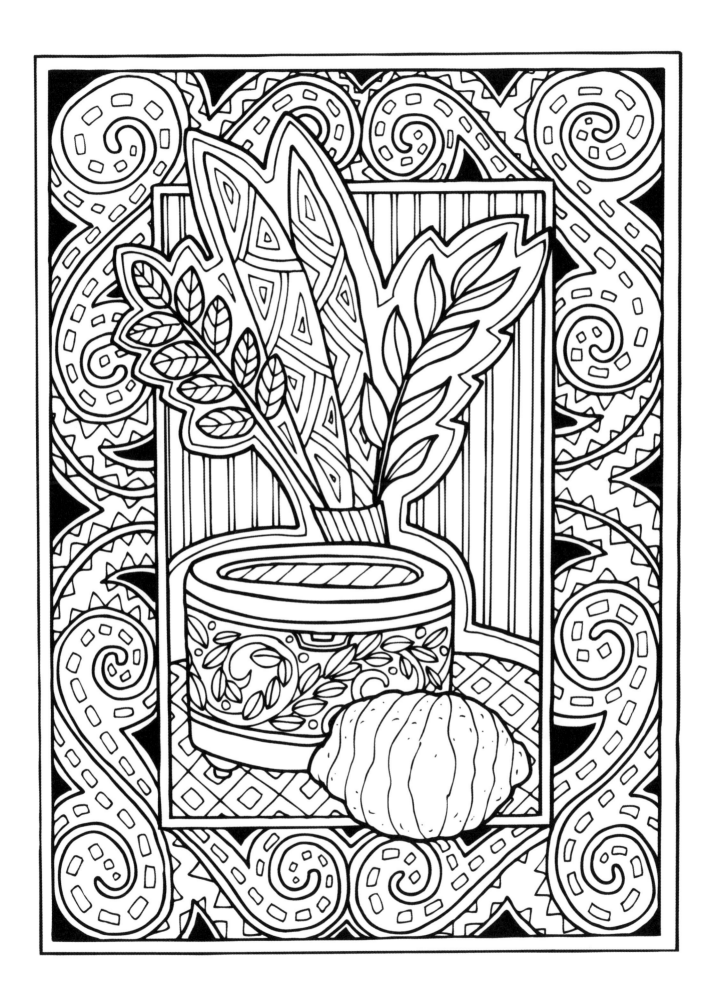

Who is wise?
One who learns from every person.

—Pirkei Avot 4:1

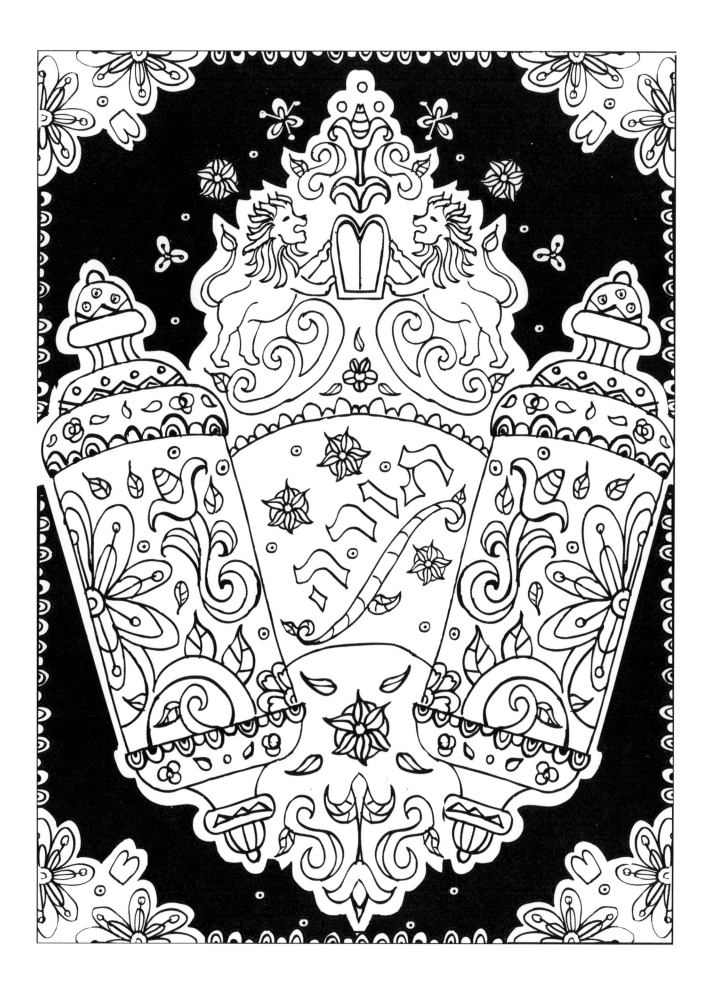

All streams flow into the sea,
yet the sea is never full.
To the place from which
the rivers flow, there they return.

—ECCLESIASTES 1:7

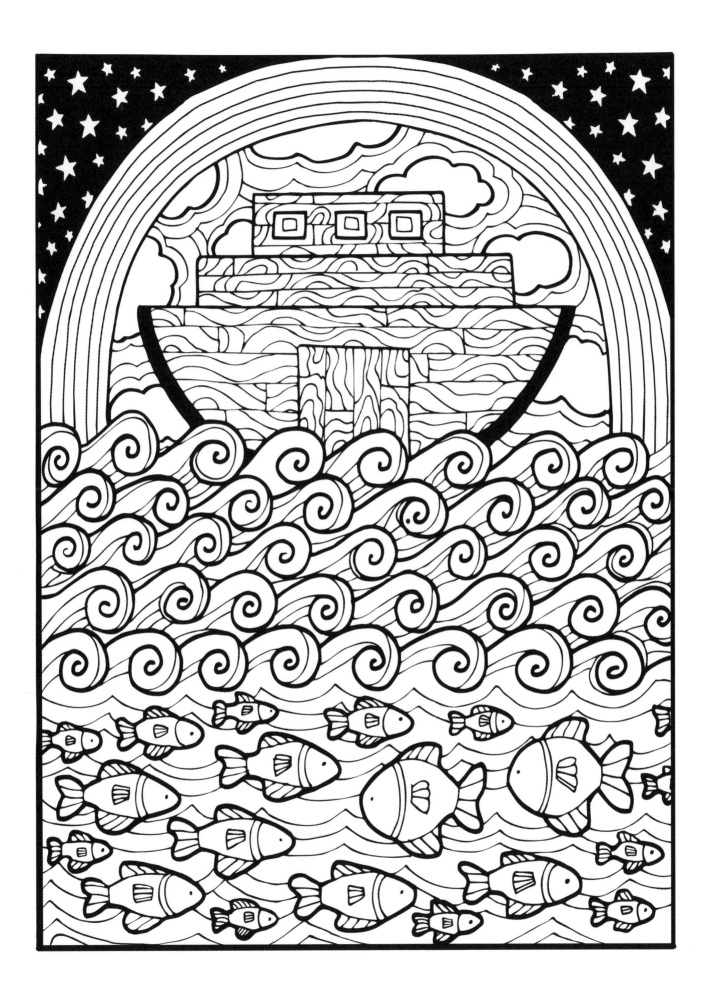

Blessed is the match consumed
in kindling flame.
Blessed is the flame that burns in the
secret fastness of the heart.

—HANNAH SZENES, FROM "BLESSED IS THE MATCH"

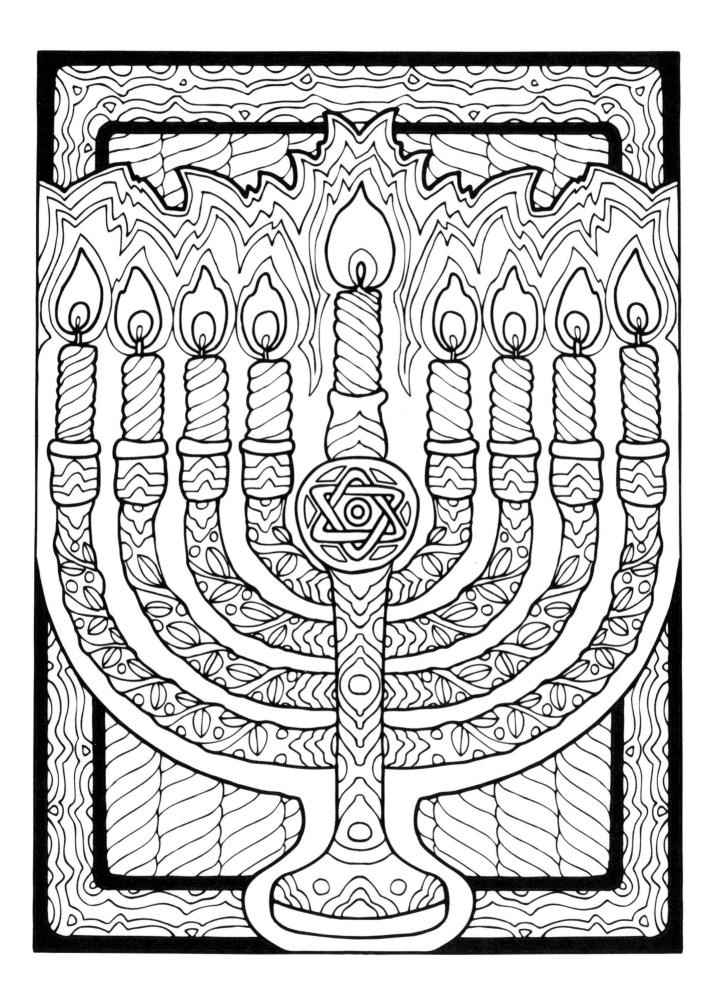

Kindle the taper like the steadfast star
Ablaze on evening's forehead o'er the earth,
And add each night a lustre 'til afar
An eightfold splendor shine above thy hearth.

—EMMA LAZARUS, FROM "THE FEAST OF LIGHTS"

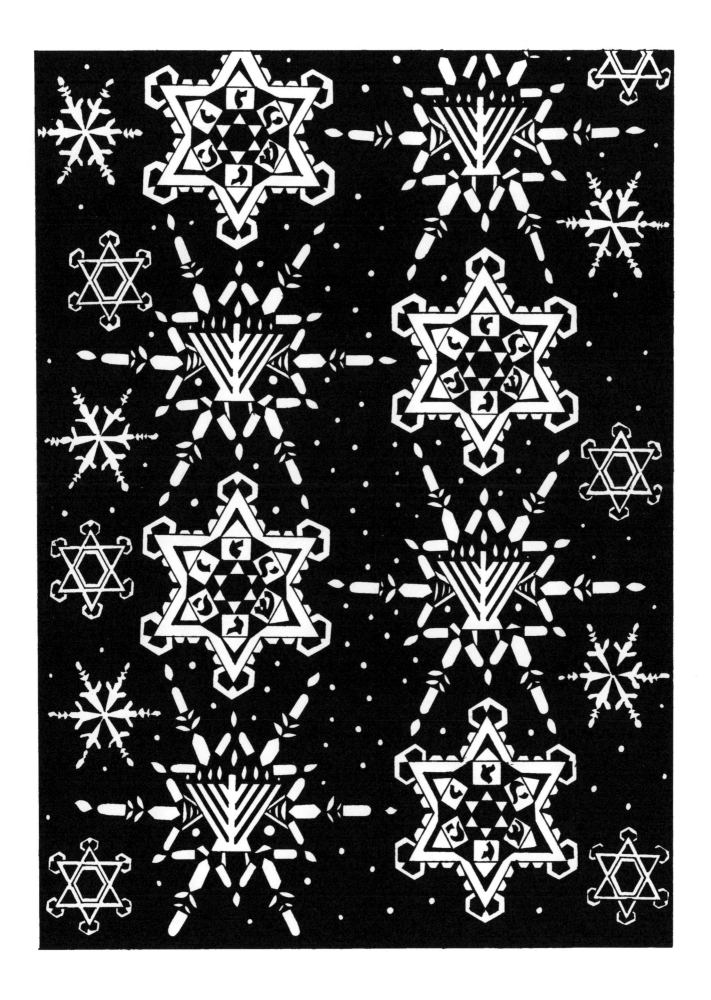

There are only two ways to live
your life. One is as though
nothing is a miracle. The other
is as though everything is a miracle.

—ALBERT EINSTEIN

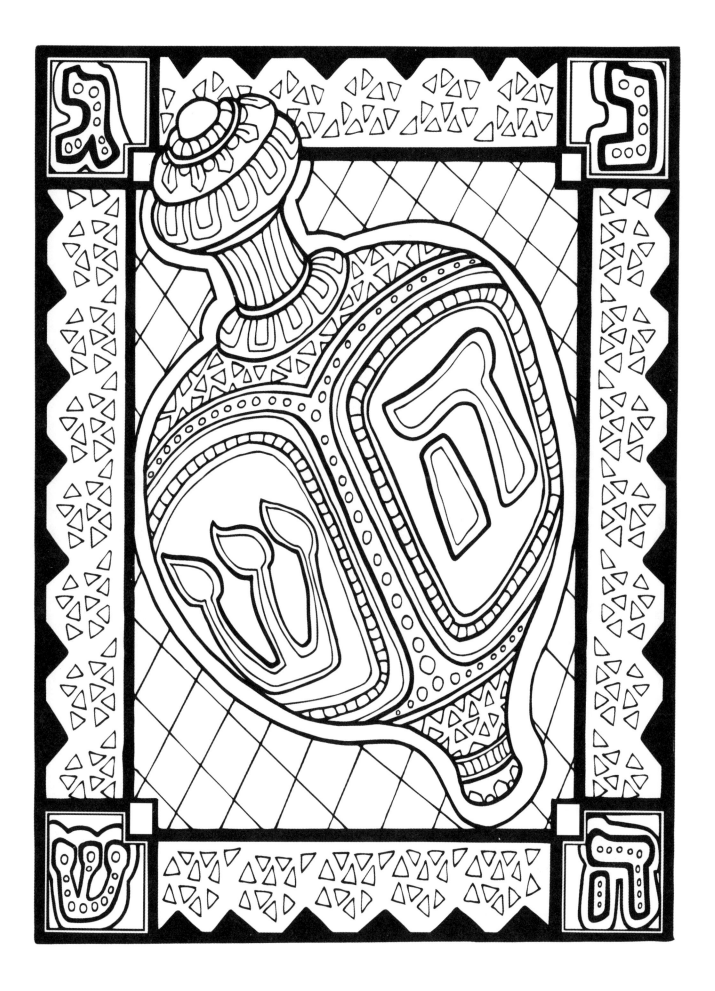

Who is honored?
Those who honor others.

— PIRKEI AVOT 4:1

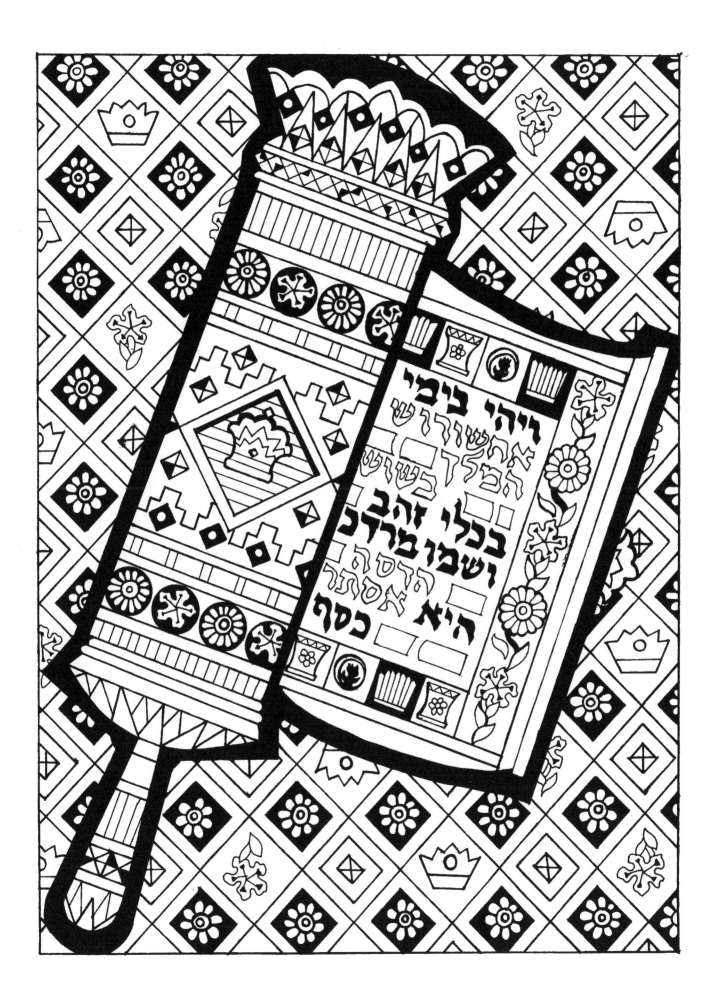

Serve God with joy;
come before God in gladness.

—Psalms 100:2

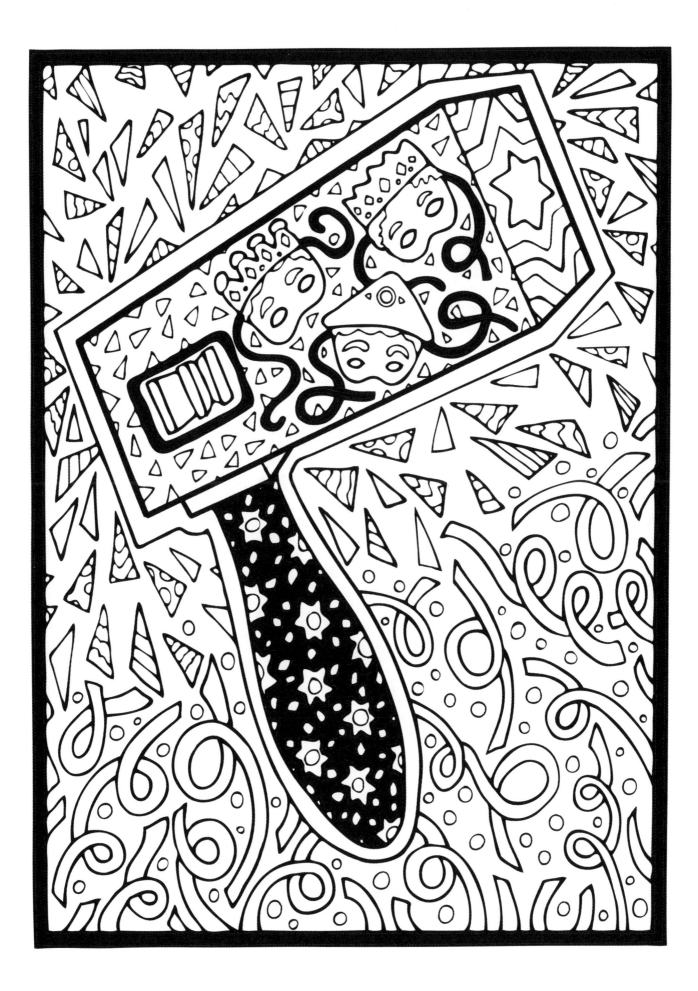

All joys hail from paradise,
and jests, too, provided
they are uttered in true joy.

—Rabbi Pinchas of Koretz

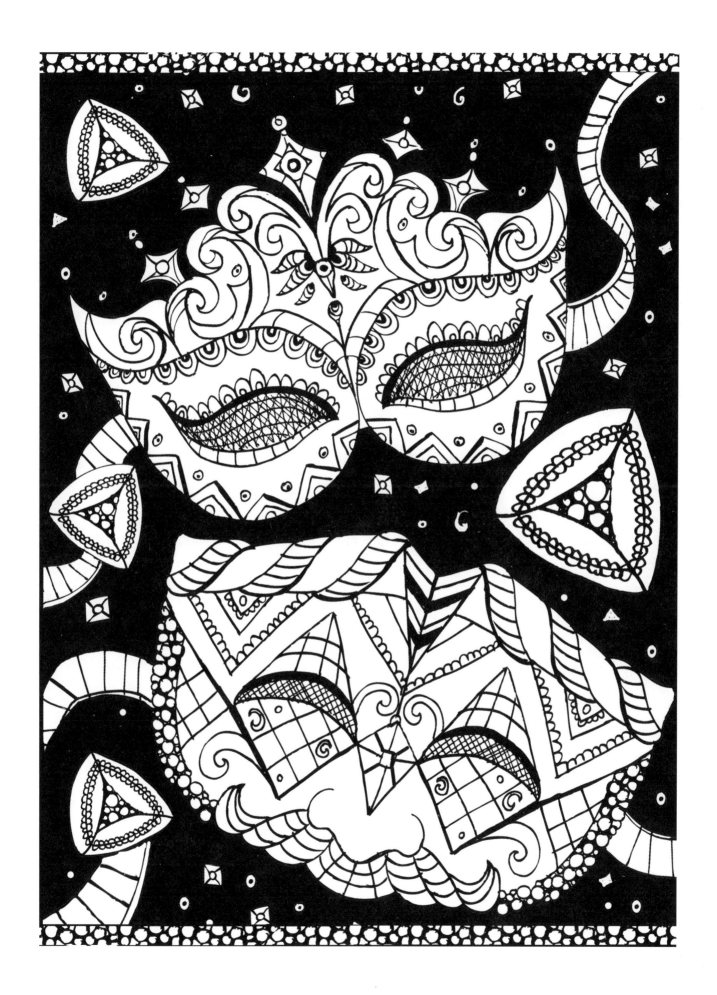

The message of Passover remains as
powerful as ever. Freedom is
won not on the battlefield but in
the classroom and the home.

—RABBI LORD JONATHAN SACKS

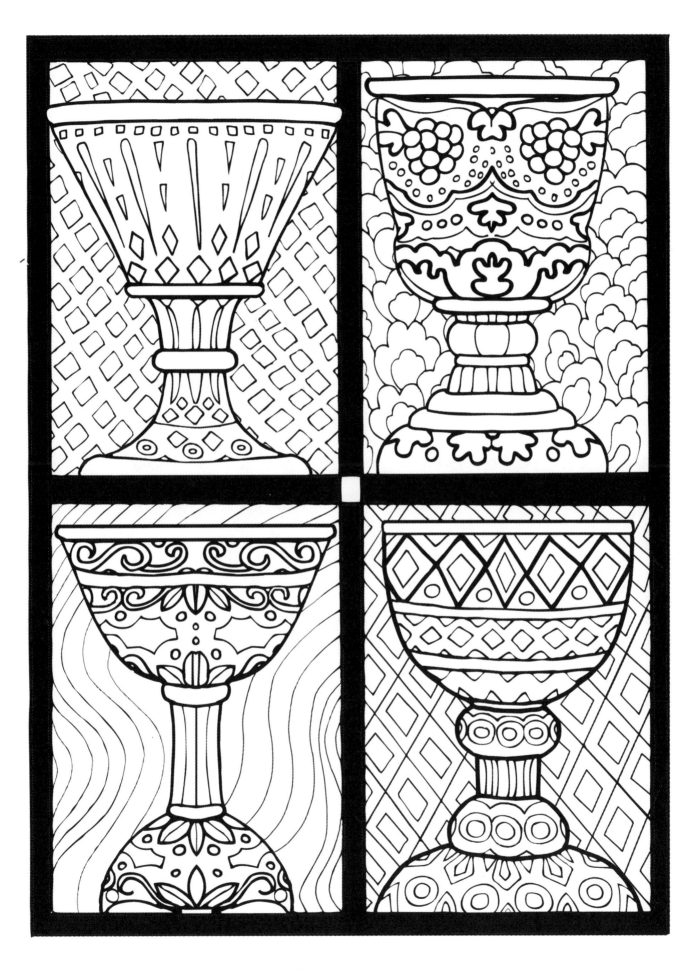

Every Jew should think of
him- or herself as having personally
been freed from Egypt.

—MISHNAH, PESACHIM 10:5

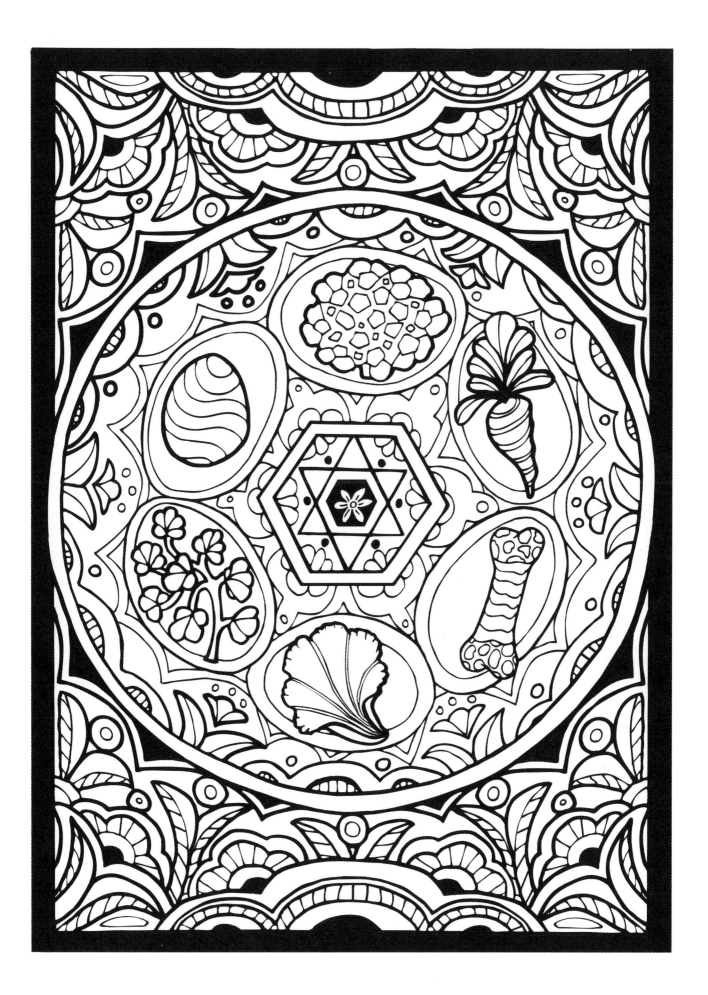

Human beings are
fundamentally communal...
[Our] choices are shaped by
our being with others.

—JUDITH PLASKOW

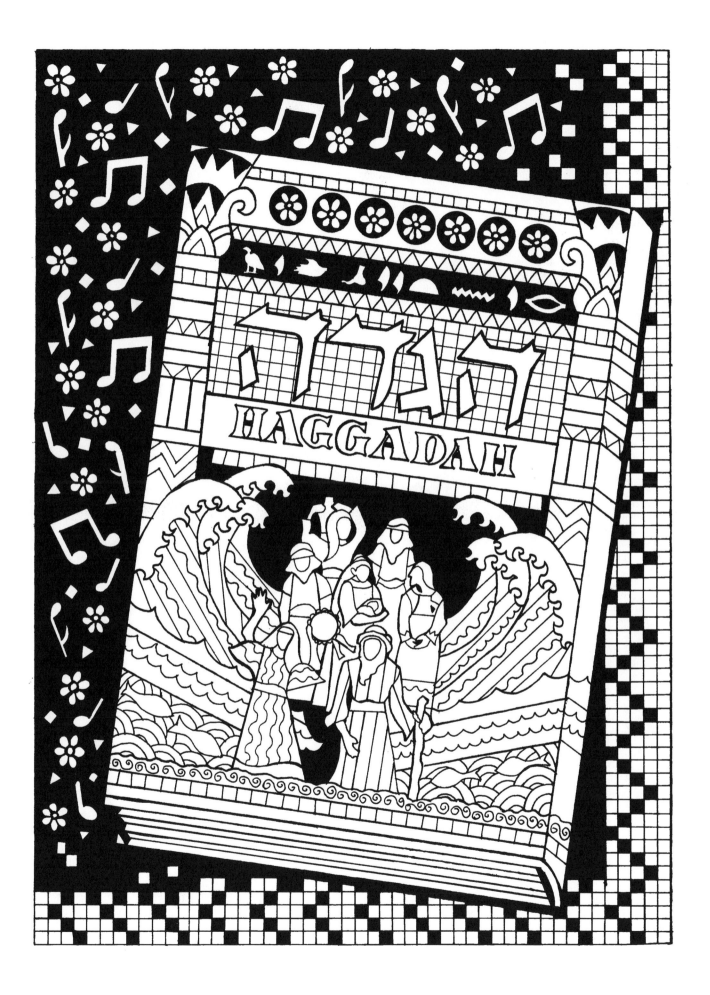

A lamp for one is
a lamp for a hundred.

—TALMUD, SHABBAT 122A

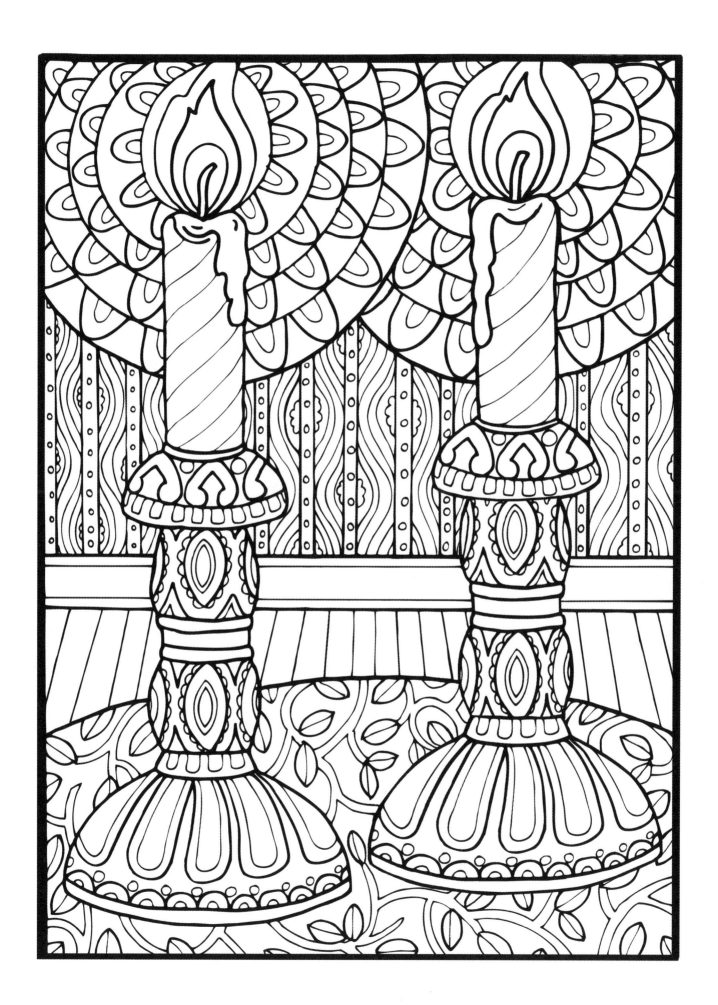

Look not at the flask but
at what it contains. There may
be a new flask full of old wine,
while an old flask may not even
have new wine in it.

—Pirkei Avot 4:27

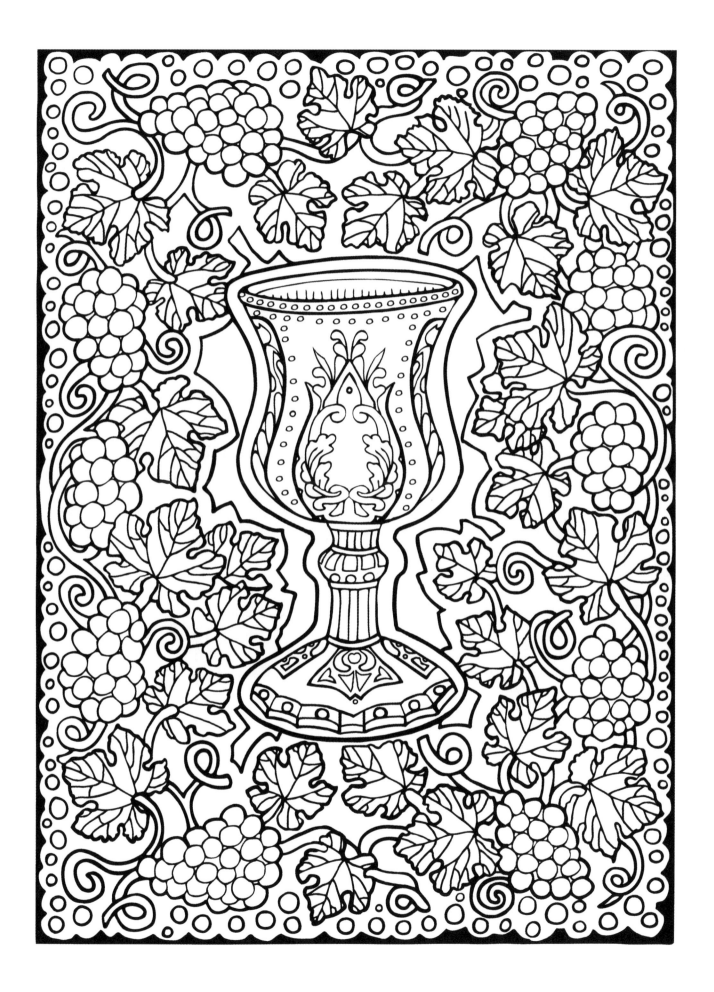

More than the Jewish
people have kept the Sabbath,
the Sabbath has
kept the Jewish people.

—ACHAD HA'AM

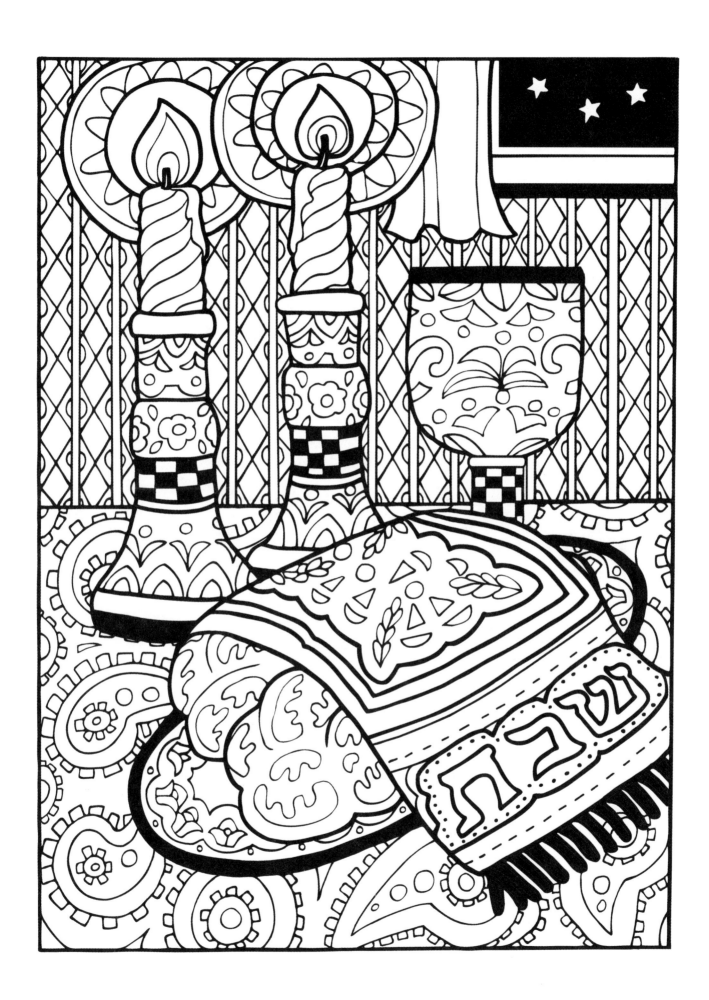

God said, "Let there be light";
and there was light.

—Genesis 1:3

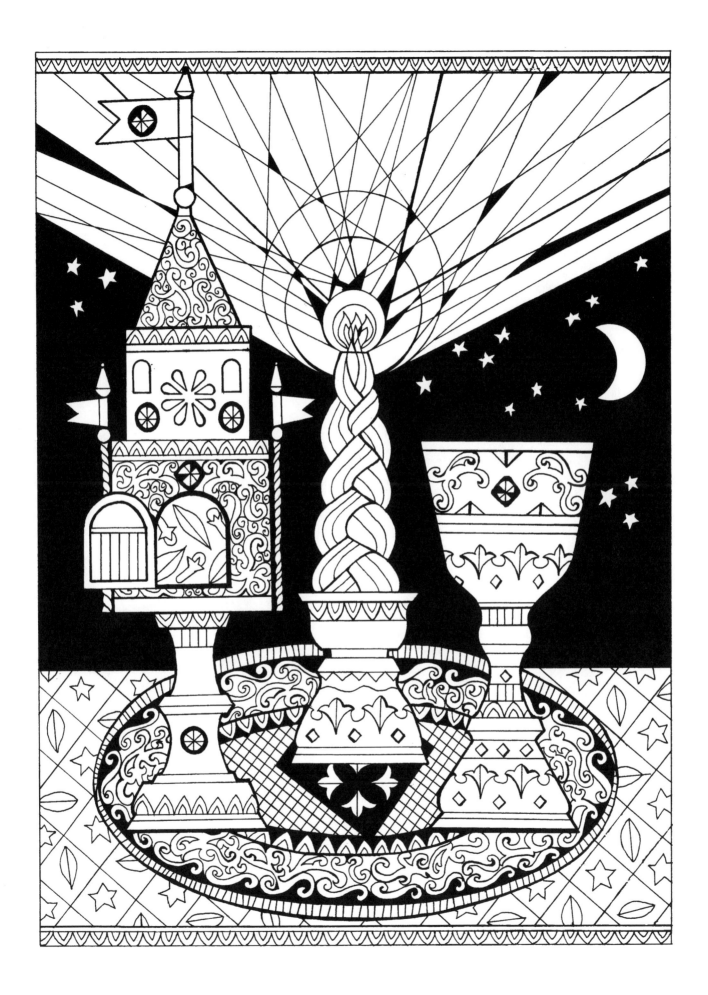

Wonder rather than doubt
is the root of all knowledge.

—Rabbi Abraham Joshua Heschel

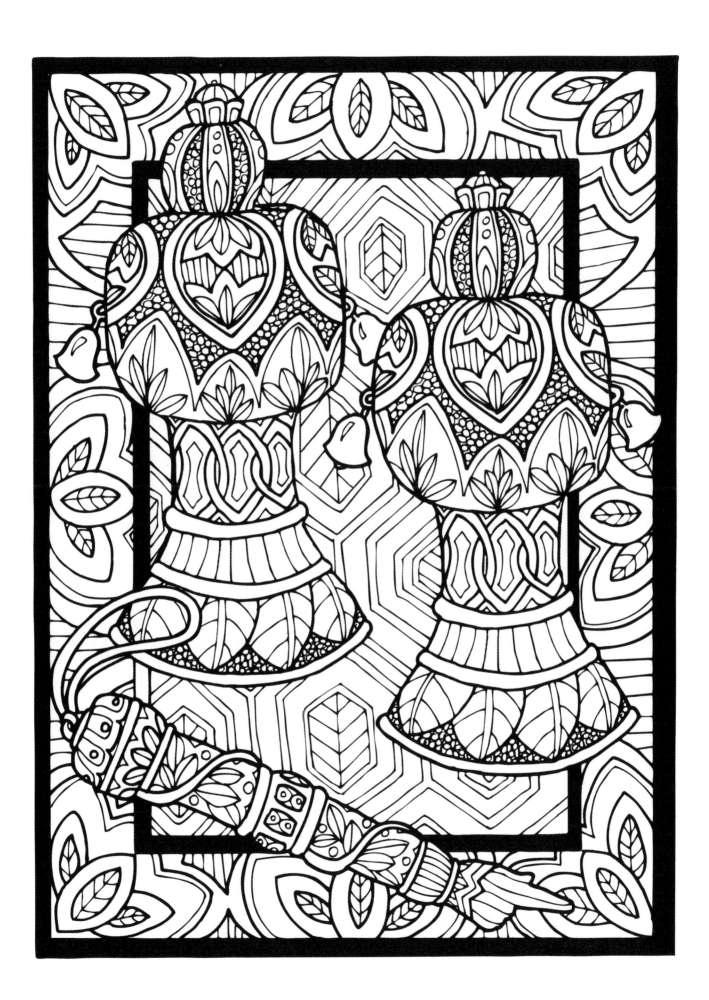

Prayer is the service of the heart.

—Talmud, Ta'anit 2a

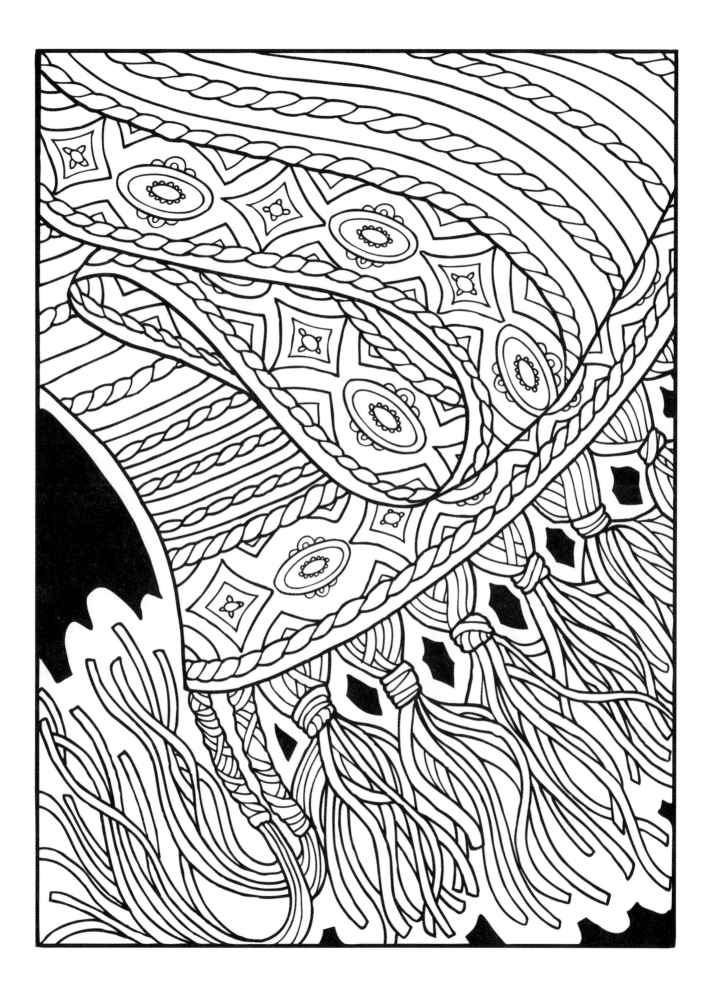

Every person must say, "The entire world was created for me." If the world was created for me, then I must consider how I can repair the world....

—Rabbi Nachman of Bratslav

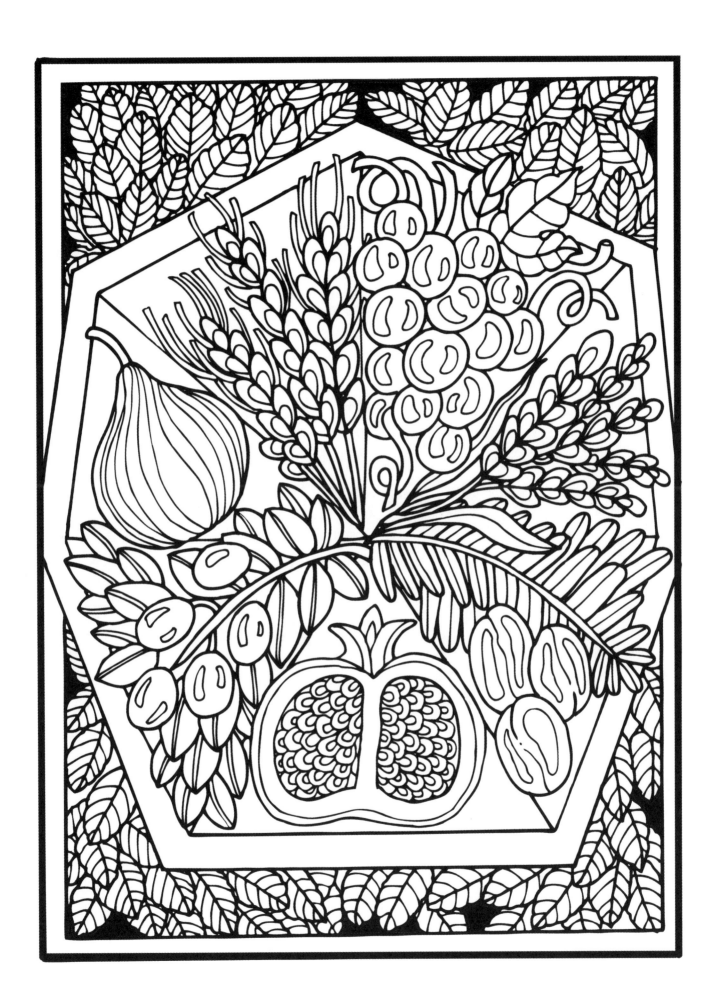

Be like the disciples of Aaron.
Love peace and pursue peace.

—Pirkei Avot 1:12

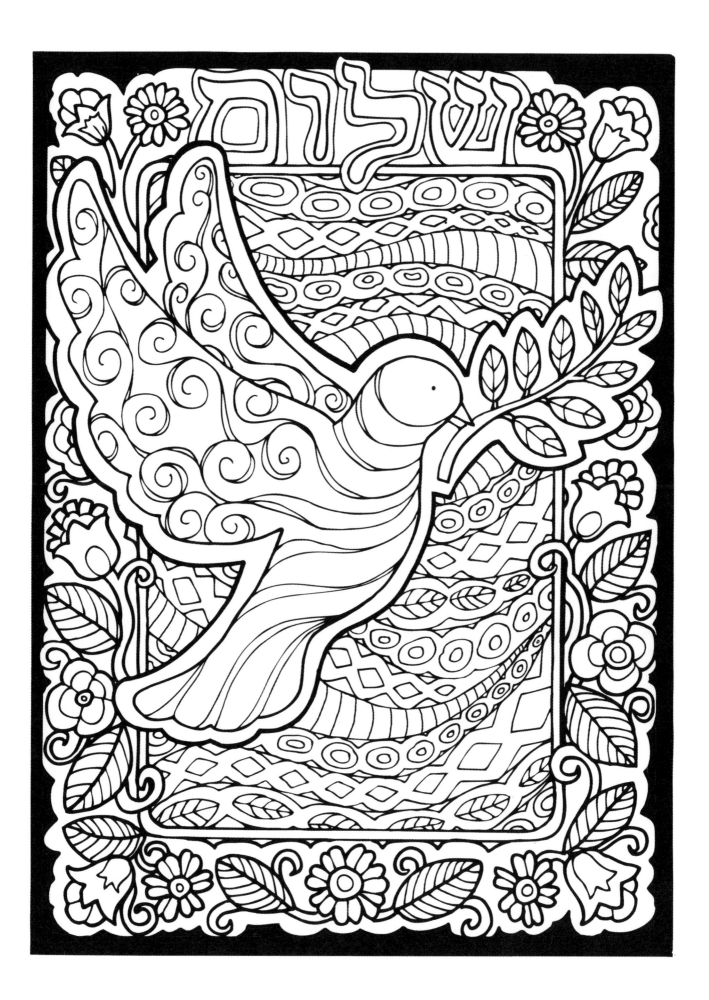

If I am not for myself,
who will be for me?
If I am only for myself, what am I?
If not now, when?

—Pirkei Avot 1:14

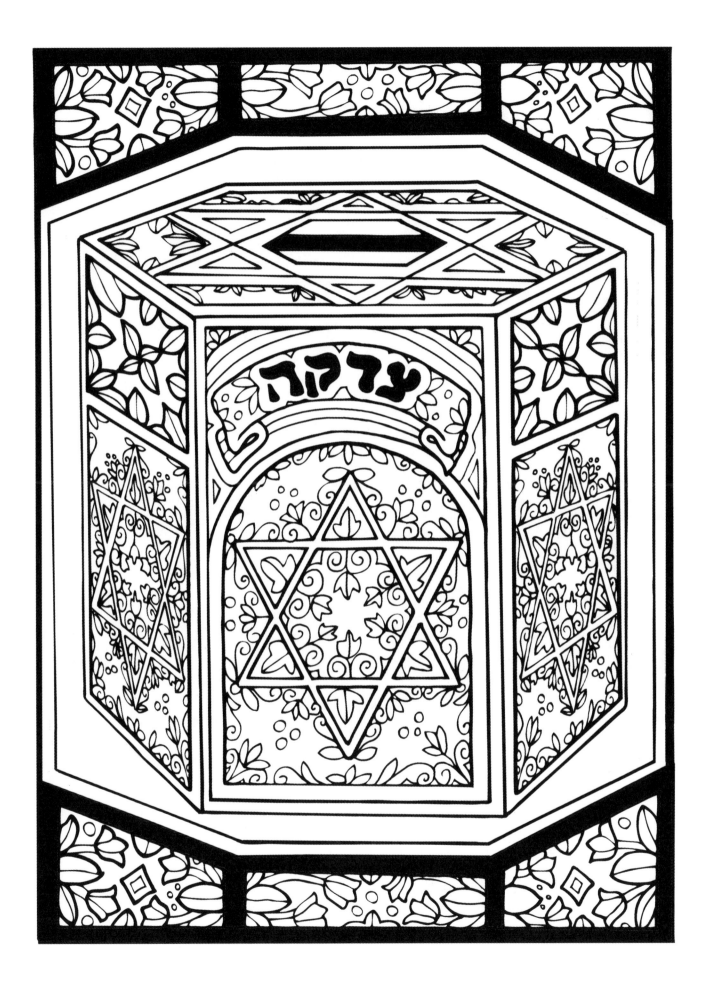

Who is rich?
One who rejoices in one's own lot.

—Pirkei Avot 4:1

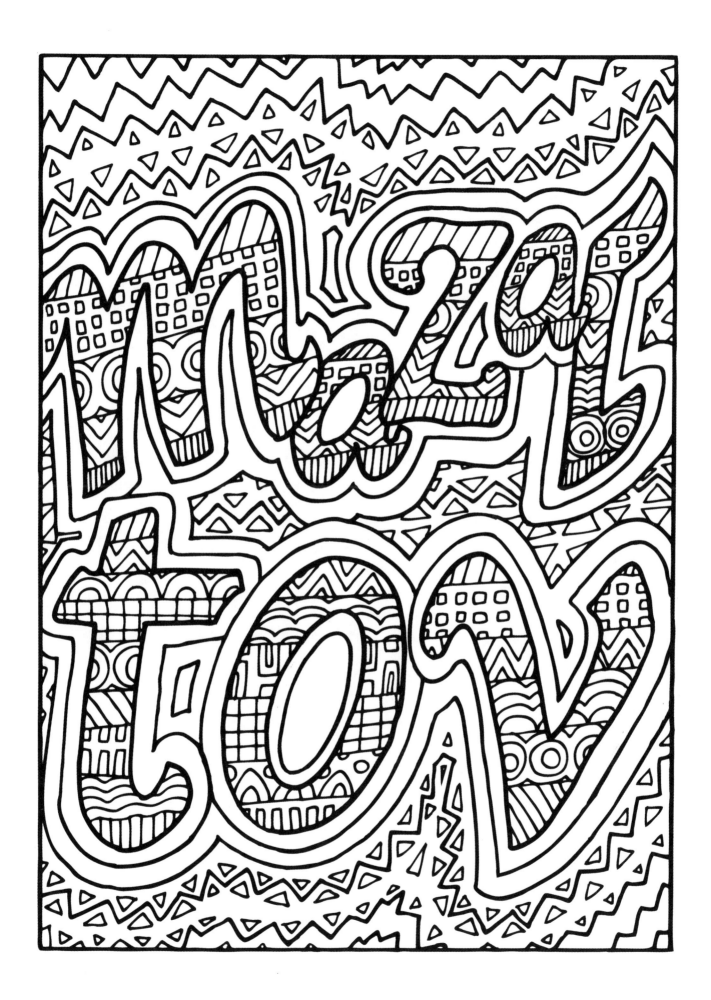

In spirituality, the searching is the finding, and the pursuit is the achievement.

—Rabbi Dr. Abraham J. Twerski

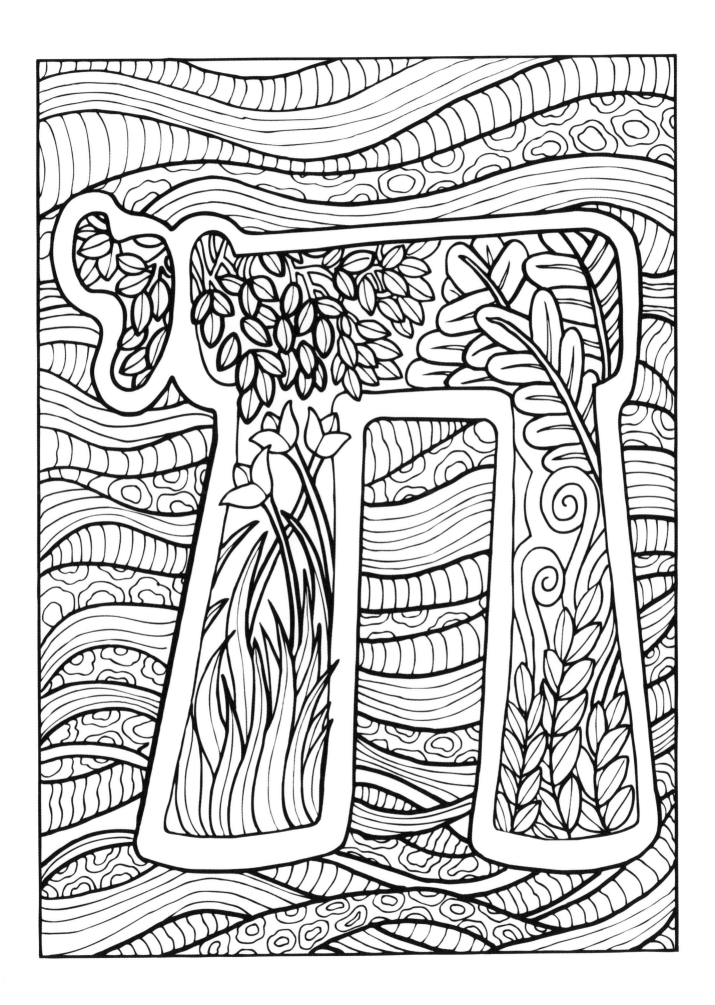

A person who has never seen
Jerusalem in its glory has never
seen a beautiful city.

—Talmud, Sukkah 51b

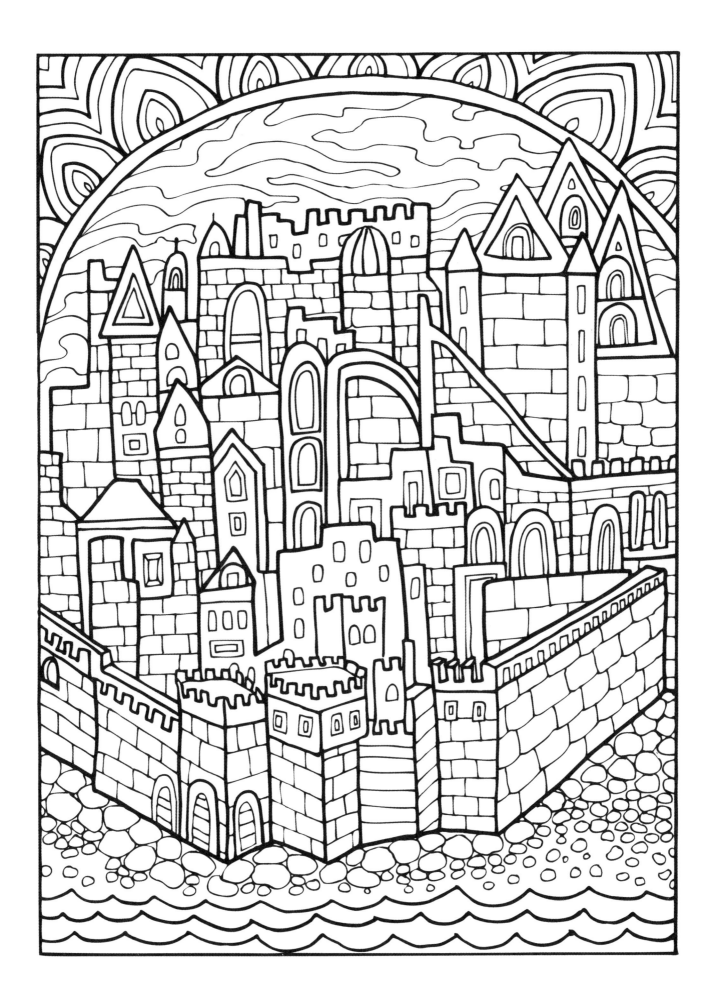

Run to do a mitzvah...
for doing one mitzvah leads to another....

—Pirkei Avot 4:2

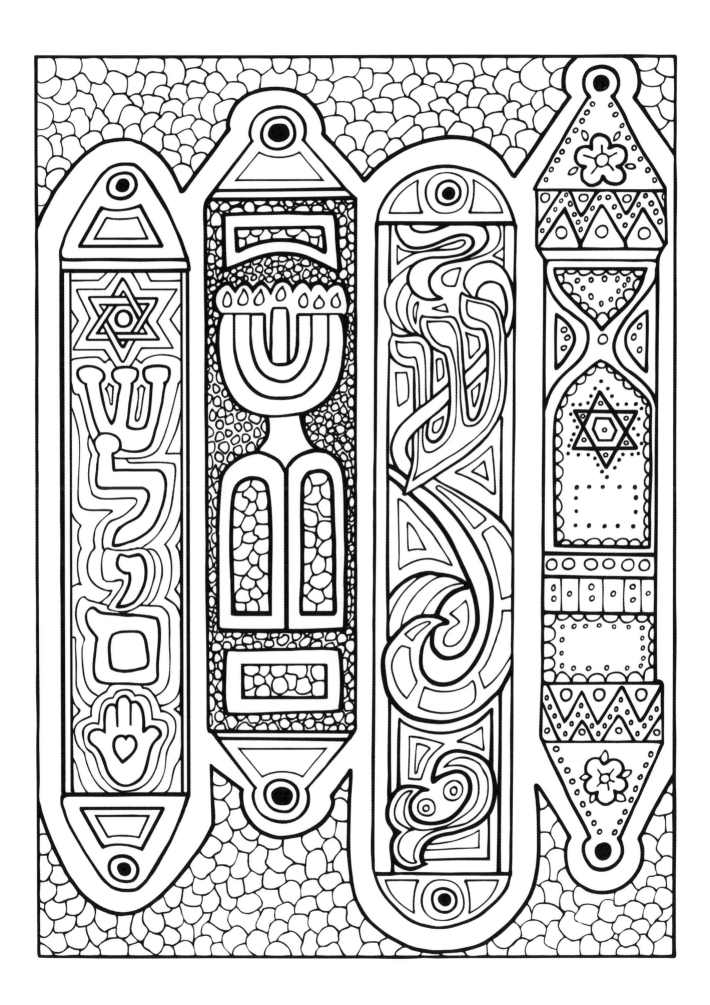

Be attached to the legions of
living things who are constantly bringing
forth everything beautiful.

—Rabbi Abraham Isaac Kook

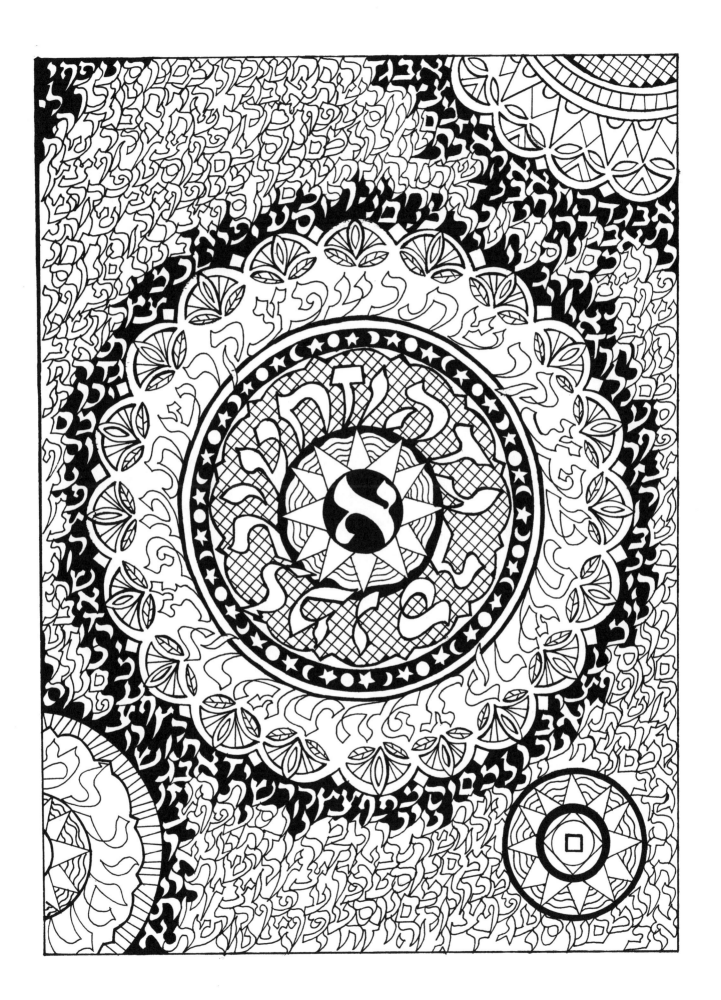

Which is the best path?...
The path of a good heart.

—Pirkei Avot 2:13

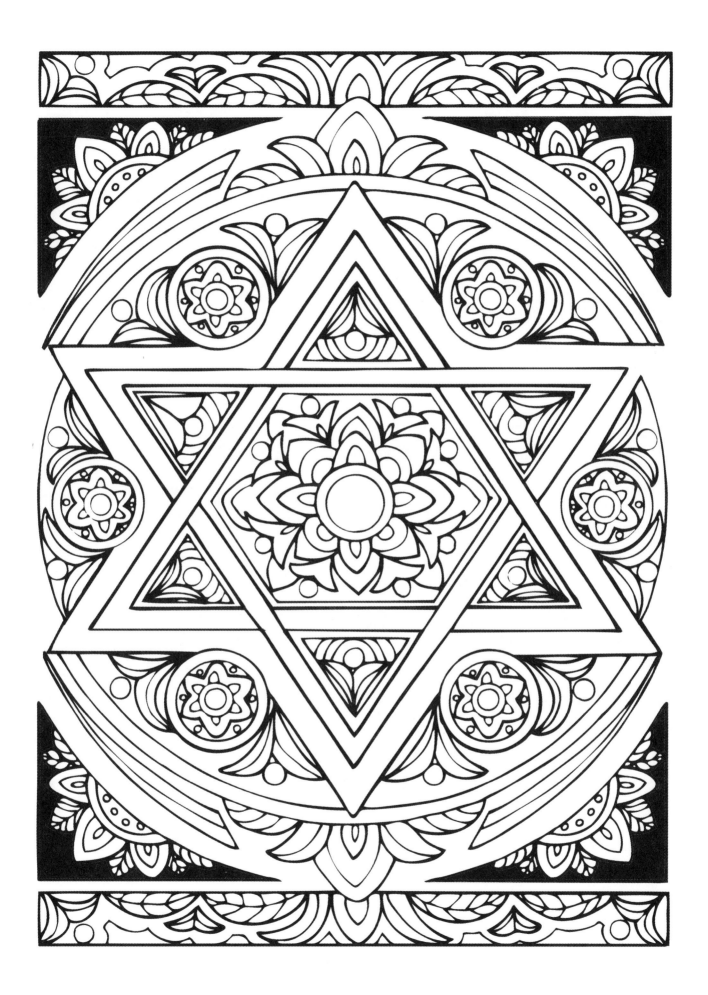

If a land has a soul, then Jerusalem
is the soul of the Land of Israel.

—David Ben-Gurion

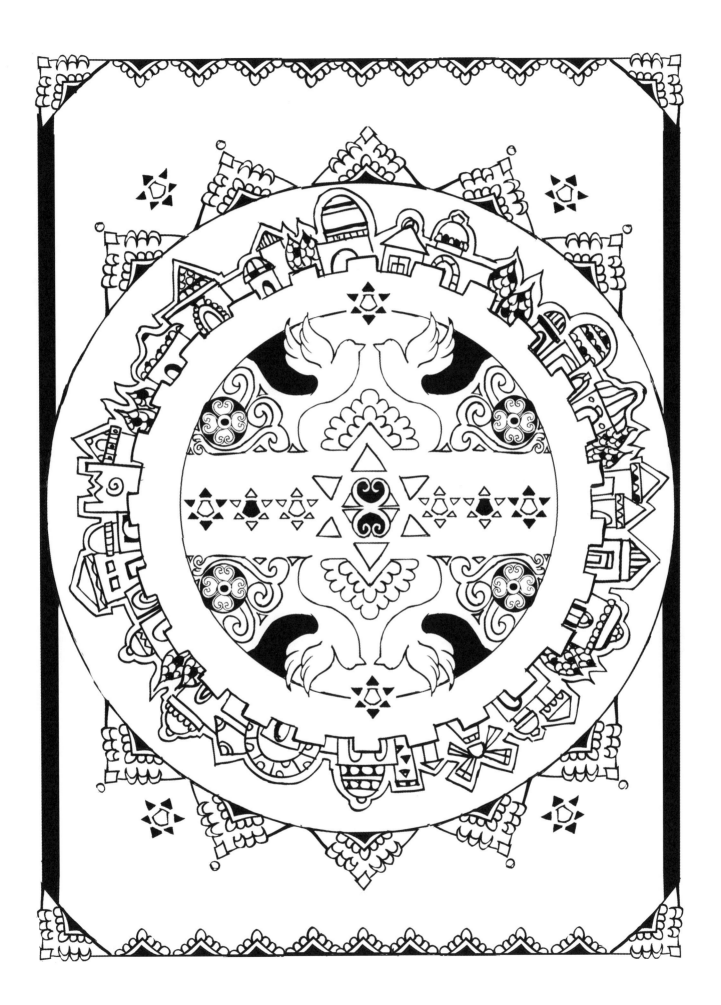

The object of the law is...
the well-being of the soul and
the well-being of the body.

—MOSES MAIMONIDES

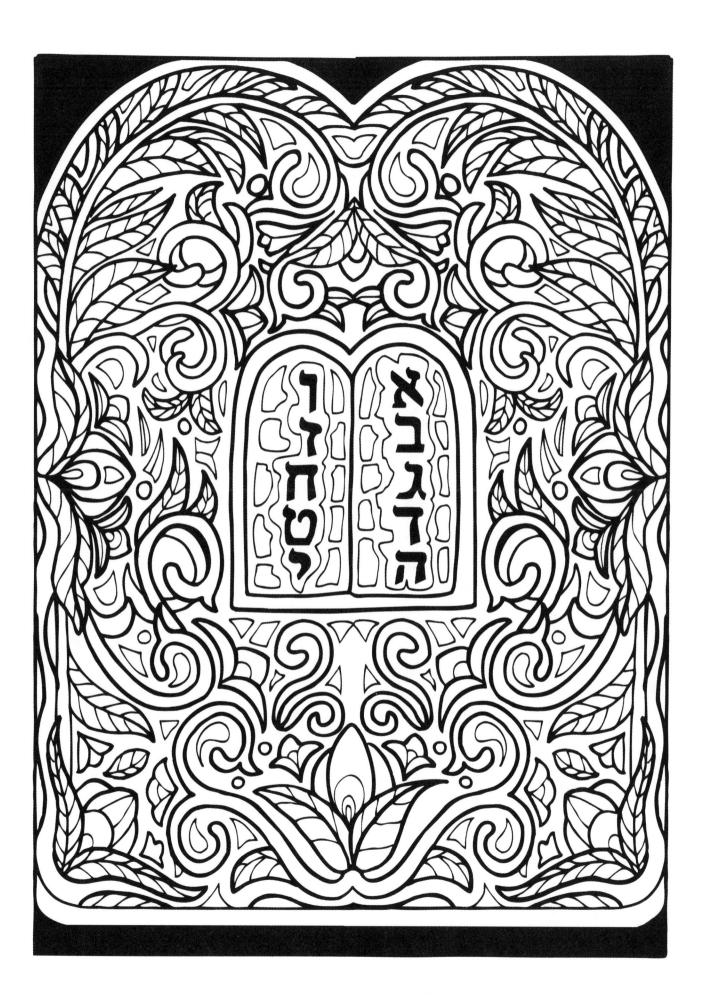

Peace cannot be kept by force;
it can only be achieved by understanding.

—ALBERT EINSTEIN

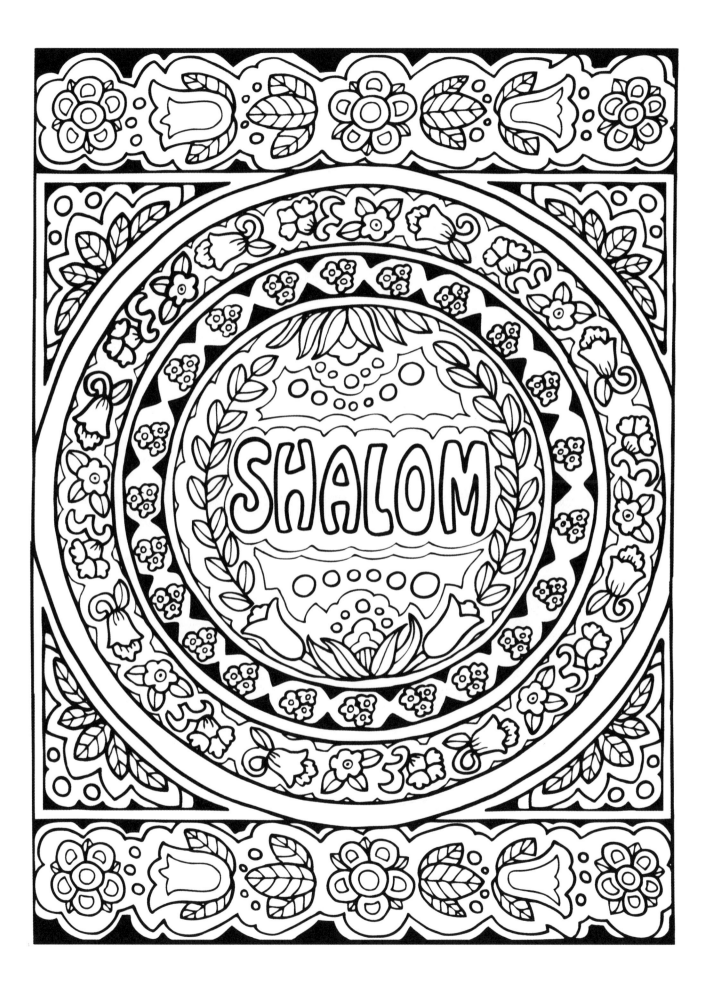

It is a tree of life to those who hold it fast,
and all who uphold it are happy.

—Proverbs 3:18

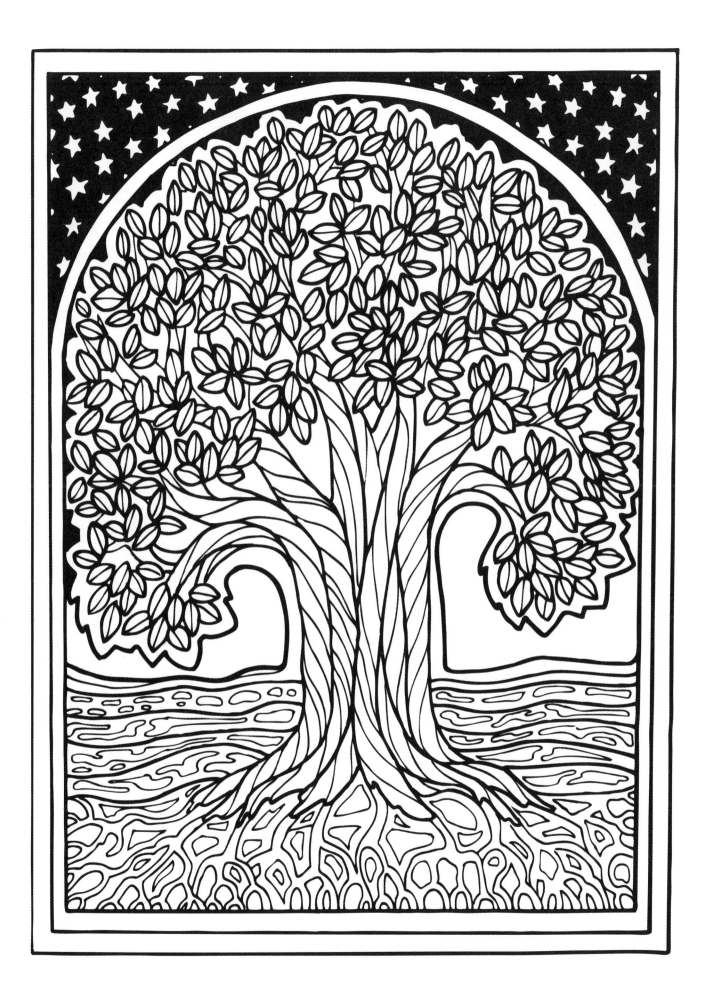